CLARICE CLIFF

Will Farmer

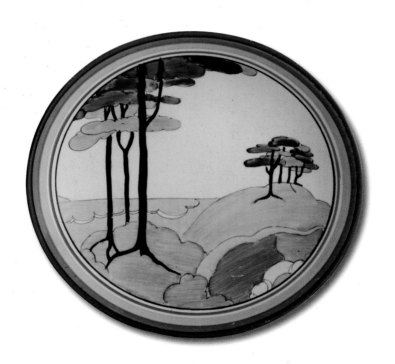

SHIRE PUBLICATIONS

Published in Great Britain in 2012 by Shire Publications
Ltd, Midland House, West Way, Botley, Oxford OX2 0PH,
United Kingdom.
44-02 23rd St, Suite 219, Long Island City, NY 11101,
USA

E-mail: shire@shirebooks.co.uk www.shirebooks.co.uk

A CIP catalogue record for this book is available from the
British Library.

Shire Library no. 590 • ISBN-13: 978 0 74780 774 2

Will Farmer has asserted his right under the Copyright,
Designs and Patents Act, 1988, to be identified as the
author of this book.

Designed by Tony Truscott Designs, Sussex, UK
and typeset in Perpetua and Gill Sans.
Printed in China through Worldprint Ltd.

12 13 14 15 16 12 11 10 9 8 7 6 5 4 3

COVER IMAGE
A group of Clarice Cliff wares in a selection of landscapes
ranging from 1930–4.

TITLE PAGE IMAGE
A dish-form circular plate hand painted on glaze in Blue
Firs, 1933.

CONTENTS PAGE IMAGE
A cigarette box and cover, hand painted on glaze in Latona
Dahlia, 1929–30.

DEDICATION
To Mum – for all the love and support along the way

ACKNOWLEDGEMENTS
Leonard Griffin, Doreen Mann, Andrew Muir, Maureen
and Harold, Brian Phillips, Adam Cunningham and Ivan
Woodward.

Images are acknowledged as follows:
Clarice Cliff Collectors Club, pages 7 (top), 13 (right), 21
(top), 38 (bottom), and 46 (bottom); Fieldings
Auctioneers, pages 3, 4, 6 (middle and bottom), 7 (middle
and bottom), 8, 11 (bottom), 16, 17, 18 (top), 19, 20, 21,
22 (bottom), 23 (bottom), 24 (bottom), 25 (top), 28, 32
(bottom), 33, 34, 36 (top), 38 (top), 39 (top), 40, 41, 42,
43 (top and bottom), 44, 45 (top right and bottom), 46
(top), 47 (top), 48, 50, 51, 52, 56, 57 (top), 58 (bottom),
62 (top left and bottom), 63 (top left and right); Leonard
Griffin, pages 11 (top) and 27; Maureen & Harold, pages
12, 13 (left), 47 (bottom), 50, 53; Andrew Muir, pages 6
(top), 10 (bottom), 14, 18 (bottom), 22 (top), 23 (top),
24 (top), 25 (bottom), 26, 30 (top), 31, 32 (top), 34
(top), 35 (top left), 36 (bottom), 37, 45 (top left), 46, 54,
57 (bottom), 58 (top and middle), 59, 60, 62 (top right),
63 (bottom left and right); Brian Phillips, page 30 (middle
and bottom); author's own collection, pages 10 (top), 35
(top right and bottom), 39 (bottom), and 43 (middle);
Andrew Hutton, page 34 (bottom).
With thanks to the Clarice Cliff Collectors Club at
www.claricecliff.com

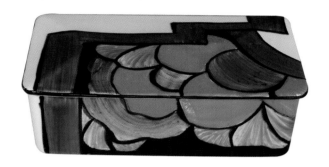

CONTENTS

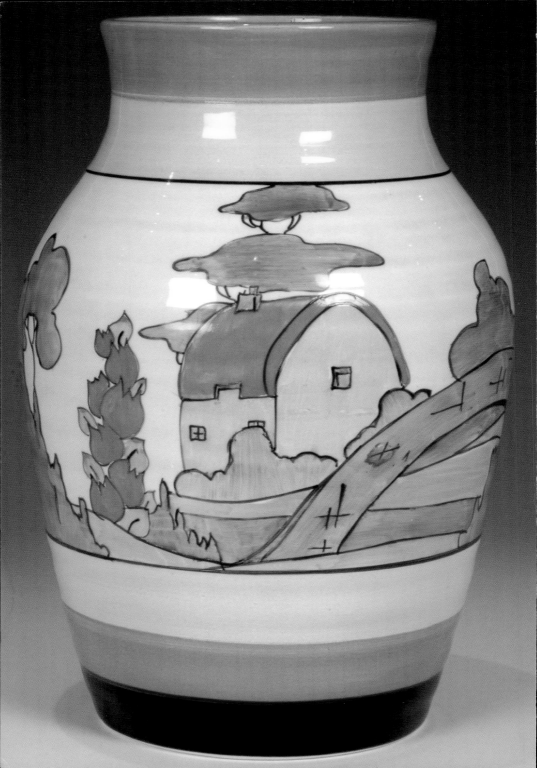

INTRODUCTION

CLARICE CLIFF is one of the most instantly recognisable ceramic designers of the twentieth century. Her distinctive 'Bizarre' pottery, with its vibrant colour palette and dynamic patterns on equally daring forms, epitomises the mood of the Jazz Age.

During the Depression, Clarice flooded homes with colour, offering her customers a glimpse of something new and exciting, far removed from the formal and staid styles of the first quarter of the century. Hers was a true success story founded on hard work, determination and an unwavering clear vision. Clarice was different, as was her ceramic art: a unique combination of inspired thought and design brilliance that created the perfect recipe for success.

Clarice was a modern and fashionable woman of her time who demonstrated that she also had the skill to be a successful businesswoman. As an industrial designer she had great intuition for what the public wanted, and between 1927 and 1936, at a time of high Art Deco, her shapes, colours and patterns 'delivered' where her competitors fell short. Whilst many other ceramic designers looked back, Clarice grabbed the 'new' with both hands: Art Deco, Modernism and Cubism. With an open mind and positive attitude she recognised the best qualities in these movements and developed them into commercially successful domestic wares.

Inspired by themes and ideas of art and design movements from around the world, Clarice's longing for change was transferred to the surface of the pots she so ingeniously created. This, combined with a shrewd understanding of business, resulted in a product that unashamedly burst onto the market, introducing the consumer of the day to an entirely new style.

Such was the demand for Clarice's work that, at its peak, the A. J. Wilkinson factory was recorded as producing 18,000 pieces a week with a turnover of £2,000, double that of her nearest competitor. Her wares were exported around the globe as far away as North and South America, Canada, South Africa, Australia and New Zealand. Towards the end of the 1930s, however, Clarice, ever wise in business, realised that the entire spirit of the

Opposite:
An Isis vase, hand painted on glaze in Orange Roof Cottage, 1932.

A group of wares comprising a pair of shape 405 bookends, twin handled Lotus jug, shape 372 vase and octagonal sandwich tray, all hand painted on glaze in Football, 1929.

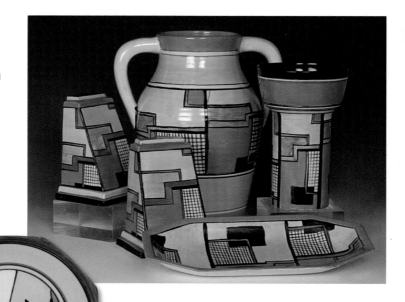

An octagonal plate hand painted on glaze in Blue W, 1929.

A shape 369 vase hand painted on glaze in Autumn (red), 1930.

times was about to change and that she could no longer be quite so daring or experimental. Her wares still continued to sell but had lost the dynamic flair and excitement of those early years. The onset of the Second World War was the final factor that took Clarice away from the work she loved. The post-war years also saw changes in taste combined with mass production techniques that left little room for labour-intensive hand-painted wares.

Today's modern approach to women in business makes it difficult to appreciate just how successful Clarice was. Colley Shorter, her boss and later her husband, was a genius at promotion and publicity, and the levels of interest and press coverage received by her products were unprecedented; over 360 articles and reviews of her distinctive Bizarre ware were published during the key years of

1927 to 1936. Compare this to one of her most well-known competitors of the day – Susie Cooper – who achieved barely twenty in the same period. In recent years a huge amount of new research has re-appraised Clarice the designer, the businesswoman and, most importantly, the artist.

In 1931, the *Pottery Gazette* hailed Clarice as 'a pioneer of advanced thought' and assured buyers that her work represented 'heirlooms of the future'. Today salerooms across the world have seen Bizarre ware realise prices not only in thousands but in tens of thousands of pounds; it appears that the *Pottery Gazette* was indeed correct! Clarice's vast legacy of pattern and form has proved her to be one of the most important ceramic designers of the twentieth century.

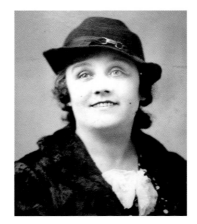

Left: An original studio portrait of Clarice Cliff, c. 1930.

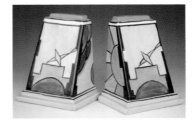

Below left: A pair of shape 405 bookends hand painted on glaze in Sunray, 1929.

Below: A Bon Jour shape early morning tea service hand painted on glaze in Solitude, 1933.

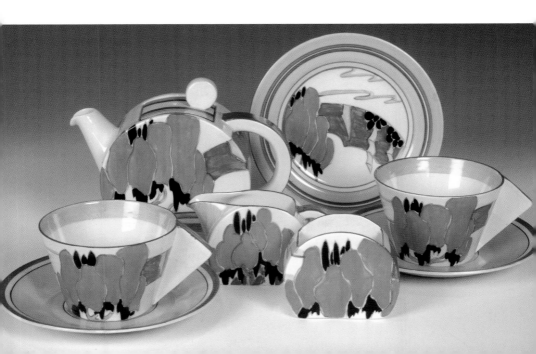

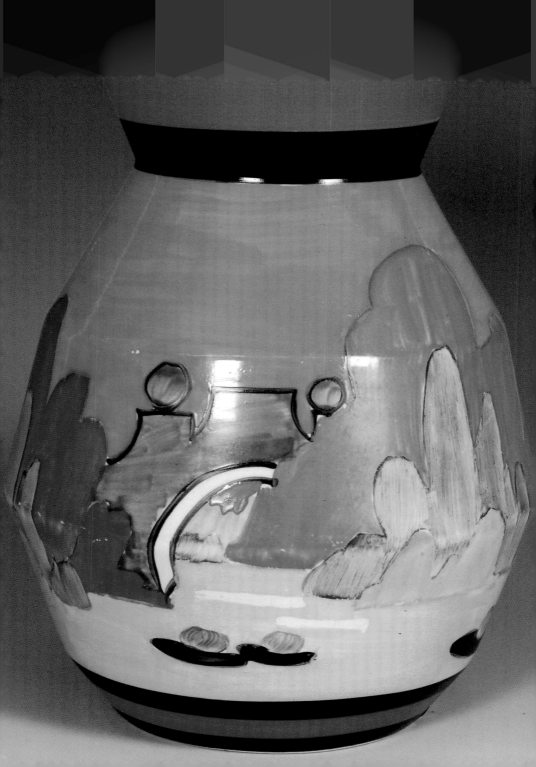

BEFORE BIZARRE

CLARICE was born in 1899 to a typical Staffordshire Potteries family and home. The daughter of Harry and Ann Cliff, she was one of seven children squeezed into a small terraced house in Meir Street, Tunstall, Stoke-on-Trent. Like the majority of people from this industrial part of Staffordshire, she began life in a 'two up, two down' home. Her father worked at the local iron foundry, whilst her mother took in washing to supplement the family income. It was a typical town with typical prospects. Children would often follow their parents' job path; many found work in one of the hundreds of 'pot banks' (pottery manufacturers) around the area. The options were few, and from an early age Clarice would have been acutely aware of the limited opportunities.

Unusually, Clarice was sent to a different school from that of her siblings; this possibly created an early sense of independence, which would later manifest itself more strongly in both her personality and career. From an early age her artistic abilities were evident and Clarice showed a desire to learn and apply her talents. Two of her aunts were decorators at a local pottery and she would often visit after school, lingering to watch the deft brushstrokes they executed so swiftly and easily. This early interest marked the start of what would develop into Clarice's lifelong career.

As part of a large family Clarice was expected to go out to work at the earliest opportunity, and at thirteen she left school to learn the skills which were to become key to her future success. Typically in the pottery trade, whether one worked as a gilder, lithographer or painter, a chosen career was seen as a career for life. Once apprenticed, workers would learn their trade to the best of their ability to ensure the greatest possible wage. However, Clarice had different ideas, and over a few short years moved from firm to firm, amassing a huge variety of skills in all aspects of ceramic manufacture.

Her first position was at Lingard, Webster & Co in around 1912 as an apprentice enameller and freehand decorator. As a seven-year apprenticeship, this commitment would have won her mother's approval. With a skilled trade and an assured future, freehand decorators were more highly regarded than

Opposite:
A shape 360 vase hand painted on glaze in Appliqué Avignon, 1930.

9

A beaker hand painted on glaze in Geometric Garden, 1930.

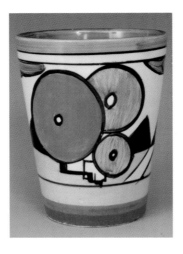

lithographers and potters, and, importantly, more highly paid on completion of their apprenticeship. Here Clarice would have learnt a variety of techniques, from brushstrokes to the application of a pattern across a range of different sized wares.

After just three years, however, Clarice moved to Hollinshead & Kirkham to take up an apprenticeship as a lithographer. As lithography was commonly seen as a lesser role, this would no doubt have caused her parents concern, but a determined Clarice was on a path of discovery that would stand her in good stead in the years to come. She spent her days repetitiously applying transfer patterns to dinner and tea wares; but for Clarice this was another piece of the puzzle, as the more skills she acquired, the better placed she would be to succeed in her career.

In 1914, Clarice won a scholarship to the Tunstall School of Art, learning under the watchful eye of Gordon Forsythe, a key figure in the British ceramics industry who was well connected with many influential people in the world of art and design.

A Stamford early morning tea service hand painted on glaze in Straight Line, 1930.

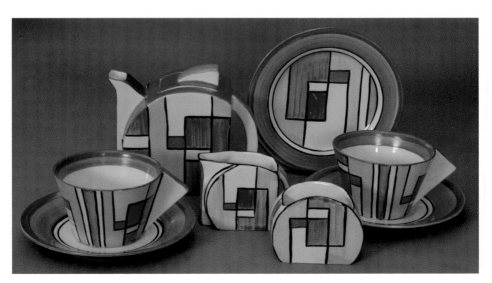

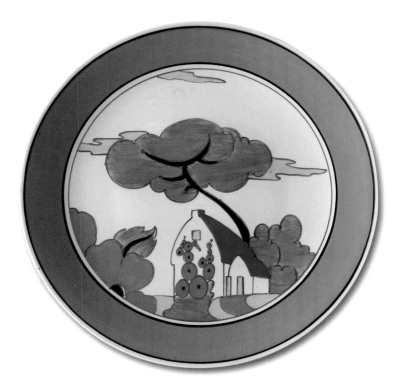

A dish-form wall plaque hand painted on glaze in Red Roofs, 1931.

A shape 358 vase hand painted on glaze in Orange Heaven (Bruna), 1931.

In 1916 Clarice made her final move, which would have an extraordinary impact on both her career and personal life, when she took a position at A. J. Wilkinson at Newport, Burslem, a successful pot bank that had been owned by the Shorter family since 1894. The factory was spread over a huge site with a mass of bottle-ovens, kilns and production shops. Employing some four hundred workers, it was situated alongside the Trent–Mersey canal where barges delivered the raw ingredients of clay and coal. The firm was run by brothers Guy and Colley Shorter, who had taken over the business from their father, and during the early part of the twentieth century it had established a reputation for fine art wares which had created a far-reaching international market.

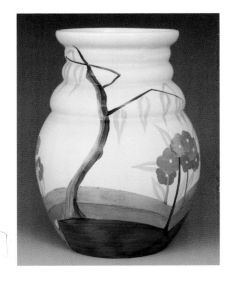

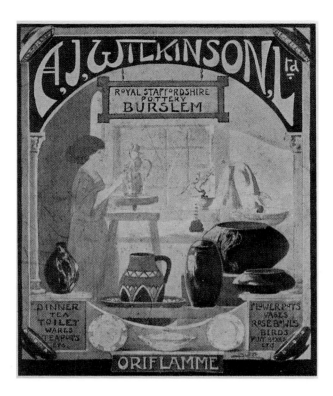

An original
A. J. Wilkinson
advertisement
promoting
Oriflamme wares,
c. 1925. The
woman shown
modelling was
probably Clarice
Cliff.

When Clarice joined A. J. Wilkinson she had already acquired four years' decorating experience as well as an accumulated knowledge of the wide range of manufacturing processes. This large factory offered her a chance to see many new processes first hand. Clarice had been appointed to a post in the lithography department, which shared a room with the other decorating processes. She would fill every moment of her spare time wandering from department to department, making friends as she went, watching and learning what each skilled worker was undertaking. Each job required its own skills: plates and saucers were pressed from solid clay; teapots and other vessels were made by pouring slip into moulds. She liked to watch the kilns being stacked and got to know oven firemen whom she could persuade to fire her early modelling work, using expensive modelling clays secretly purloined for her by Reg Lamb who worked in 'the clay end', the worst part of the factory.

The decorating shop where Clarice worked housed both the lithographers and the hand paintresses, enabling her to watch the skilled artists deftly hand decorate the earthenware. Her independence and ambition to design eventually attracted attention, when, at a fortuitous moment, the works manager, Jack Walker, passed through the decorating shop whilst Clarice was painting a butterfly freehand onto a vase. A skilled artist himself, he instantly recognised Clarice's talent and showed the piece to Colley Shorter. Equally impressed, Shorter moved Clarice from the decorating shop to work with the firm's two designers, John Butler and Fred Ridgway.

Clarice's progress was so impressive that on 1 September 1922 she was formally indentured as a modeller, a step which, in addition to providing her with a wage increase, marked her intention to become a designer. This signified a great deal both to Clarice and the workforce around her. With

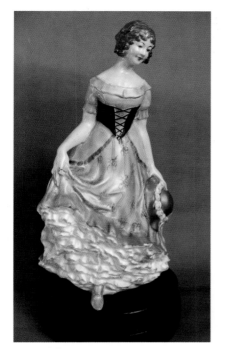

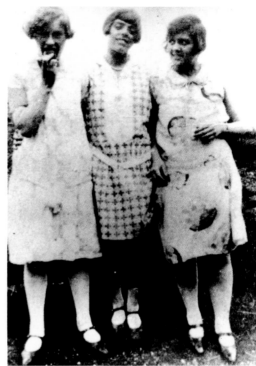

this move, she had not only opened the door to a world of new opportunities, materials and techniques, but also crossed a class and sexual divide, in a world where such opportunities for young working-class women were virtually unknown.

Clarice was now put in charge of keeping the pattern and shape books up to date and worked with John Butler producing Tibetan and Oriflamme ware, which was used to gain recognition for the company at prestigious shows where the main products were printed tableware. Butler, a skilled artist, nurtured Clarice's hand-painting skills, and as early as 1924 asked her to work on a special exhibition piece of Tibetan ware. She spent many days intricately outlining a massive ginger jar with gold, decorating it with fine spiders' webs and insects.

Plucked from the obscurity of the decorating shop, Clarice now had to progress into unknown territory with only her determination as a guide. Her confidence and experience quickly grew, as she worked on modelling, firing, and experimenting. From 1924 onwards she created a number of figures, vases and bowls that were put into production, and these were to change dramatically the fame and fortunes of Newport Pottery.

Above:
An original photograph showing Clarice Cliff aged 17 (right), with friends in 1917.

Above left: A figure of a woman in period style dress titled Victorian lady, hand painted on glaze, 1925.

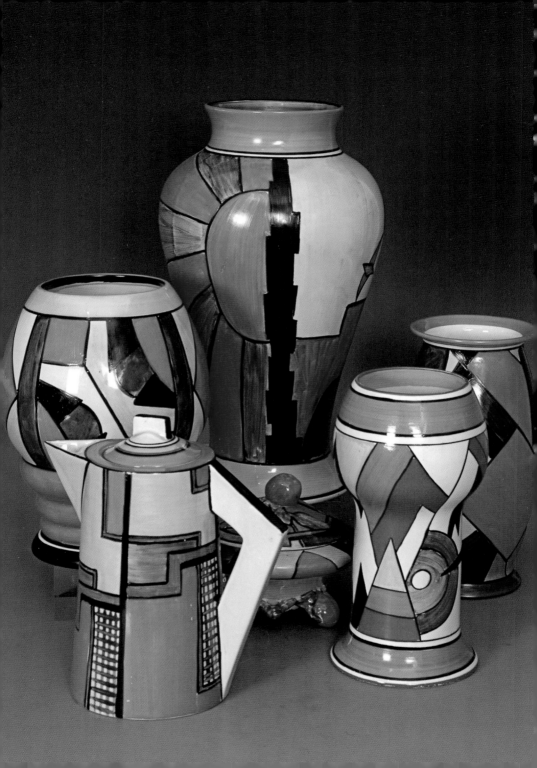

THE BIRTH OF BIZARRE

CLARICE CLIFF'S amazing 'Bizarre years' were born out of one of the most difficult times for the Staffordshire Potteries: the aftermath of the 1926 Miners' Strike. The shortage of coal dramatically affected factory production levels and alternative solutions had to be found. At the same time Clarice saw the potential of a mass of old undecorated stock acquired by A. J. Wilkinson when they bought the neighbouring Newport Pottery. This undecorated 'white' ware was traditional in shape and sub-standard, with imperfections and faults to both the glaze and the body. Clarice suggested to Colley Shorter a simple but effective use for it. Earlier in her career she had used gilding as a means of disguising small faults on the Oriflamme wares. This simple, yet centuries' old tradition (often used by early European manufacturers to save wasting good wares) could be adopted to make use of the old Newport Pottery stock. Colley agreed to the experiment and early in 1927 a studio was provided on the Newport site along with a young paintress, Gladys Scarlett, to assist. In a style very different from the subtle gilding of her earlier work, Clarice set about developing a range of designs with bold blocks of vibrant colour in interlocking triangular forms with banding added to cover the rest of the body. Each piece was quickly outlined and the colour heavily filled in to cover any imperfections; the brushstrokes were definite and obvious, which was to be used as a selling point. This style was far removed from the traditional Potteries ware, and the results were instant, dramatic, and most importantly, effective.

At the same time Colley Shorter sent Clarice to the Royal College of Art in London. Conscious of her lack of formal training, Colley saw this as an opportunity to develop her natural abilities. Clarice's time in London was significant, not only for the tuition she received but also for the life she experienced. London was bursting with colour, fashion, and people with fresh, modern ideas. This metropolis, which contrasted so strongly with the life she knew back in the Potteries, opened her eyes to a world beyond the factory gates. Every spare hour was spent taking in the most fashionable shops with their dramatic displays of the latest trends from Europe, or walking

Opposite:
A group of wares, all hand painted on glaze in a selection of early abstract designs, 1929–30.

15

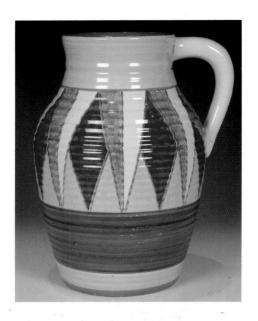

A single-handled Lotus jug hand painted on glaze in Original Bizarre, 1928.

around the many art galleries, viewing breathtaking exhibitions of modern art. This mass of pattern, colour, shape and form undoubtedly seared itself on Clarice's mind, ready to be translated onto the surface of the pots at the factory.

Clarice returned to Stoke-on-Trent a different woman. Her time in London resulted in an outpouring of ideas, and she held many long discussions in private with Colley in her studio outlining her plans for the development of her new pottery. Plagiarism was rife in the Potteries and it was commonplace for rival firms to copy new ideas, so the development of Clarice's ideas was conducted in secrecy, behind closed doors. Whilst this protected new ideas, it also provided Clarice and Colley with a valid reason for their privacy. This confidential nature of these discussions meant that Clarice and Colley found themselves enjoying a degree of privacy that was unusual for their time. After all, this was 1927, and it was socially unacceptable for an owner of a works, married with two children, to be mixing with a single woman, seventeen years younger, from a working-class family.

By the summer of 1927 Colley Shorter, a master at promotional ideas, was working on a marketing plan to launch the wares. He decided that a name should be found and Clarice suggested 'Bizarre', inspired by some seventeenth century prints by Giovanni Batista Bracelli from a series called 'Bizarrie' that she had seen in London. The words 'Bizarre by Clarice Cliff' were now added in rust red paint on the base of each piece.

The use of Clarice's own name to promote the range was one of Colley's most significant achievements. This may have arisen from an earlier trip they had secretly taken together to Paris, where they would have both been exposed to the massive quantity of artist-led wares which clearly bore the name of their creator. By adopting this practice, Colley was adding not only an identity to the pieces, but also prestige. It created a direct link between the consumer and the artist, something unique in the history of the Staffordshire pottery industry. This was an acknowledgement of wares designed for women by a woman!

Clarice chose to keep the Paris trip confidential until later in the thirties, when, in an interview with a journalist she revealed that she had only 'been abroad once, to Paris'. This trip was clearly significant, not only for the

development of her work but also for her relationship with Colley.

By October 1927 there was a sufficient supply of 'stock' for the next stage in the process – sales. It was time to launch 'Bizarre'. Colley decided to enlist the skills and sales expertise of his top salesman, Ewart Oakes, a long-time employee of the firm who serviced all the southern area customers except London. Oakes was initially sceptical about the potential success of such vibrant, even gaudy wares, but knowing his employer's skill in business and being acquainted with Clarice herself, he was evidently prepared to try.

Ewart Oakes was unable to drive (he usually used the railways to visit customers) so Colley Shorter provided his own chauffeur and car, which was loaded with samples. His first call was on William Baker & Co., of Oxford, who at the time employed a female buyer for their china and glass department. Her reaction to the wares was instantly positive. Oakes recalled afterwards that she had been 'agog' at the Bizarre wares, purchasing a full car-load on the spot, and placing an order for delivery the following February.

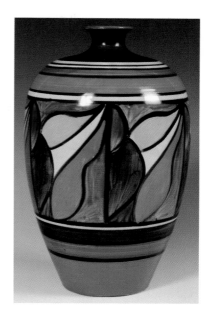

A shape 4 vase hand painted on glaze in Original Bizarre, Whisper variant, 1928.

This positive reaction was to add impetus to an already busy workshop and Clarice recruited more young paintresses to execute her designs. She quickly moved on from the simple geometric patterns to more adventurous ideas. At the same time a more professional back-stamp was created which proclaimed 'Hand Painted Bizarre by Clarice Cliff, Newport Pottery, England' with a facsimile of Clarice's own signature. In addition, a new warmer glaze for the white ware, called 'Honeyglaze', was created. A special backstamp was made for this in the same style as that of the Clarice 'signature', and sometimes both backstamps were added to a piece of ware.

An article in the *Pottery Gazette* of March 1928 appears to be the first to mention this 'new range of wares' with both an air of admiration and an anticipation of a change in taste and style. Soon the term

A Clarice Cliff Bizarre backstamp.

'Bizarre' became an umbrella name for the whole outpouring of Clarice's fervent imagination. Clarice wanted to enlarge the Bizarre range and gradually built a library of source material to help inspire her in her studio. Colley agreed to the purchase of various books and journals that covered topics such as flowers, modern art and graphics. Most important was the acquisition of a number of highly important portfolios including *Nouvelles Variations* by Eduard Benedictus and

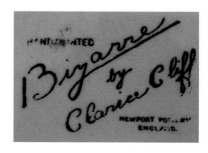

The cover to Serge Gladky's folio of designs *Nouvelles Compositions Décoratives*, formerly the property of Clarice Cliff, c. 1928.

A group of wares comprising shape 369 vase, YoYo jug, single-handled Lotus jug, Conical sugar sifter, shape 468 serviette holder or cigarettes and matches, and a selection of 177 miniature vases, all hand painted on glaze in Crocus, 1928–31.

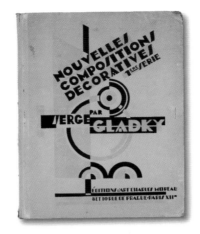

Nouvelles Compositions Décoratives (1st Series) by Serge Gladky. The creations these portfolios inspired, combined with Clarice's intuitive use of colour and form, dramatically accelerated the development of Bizarre.

In August 1928 Clarice and Colley organised a demonstration of hand painting in the foyer of the Waring & Gillow store in London. This type of promotion was highly unusual, and ingenious in its simplicity. Most contemporary manufacturers had, until then, used static displays in store to promote wares; this simple yet daringly effective idea would soon be adopted by other firms. The arrival of a team of pretty young girl paintresses must have caused a sensation! The Waring & Gillow demonstration was probably the first time Clarice did hand painting in public

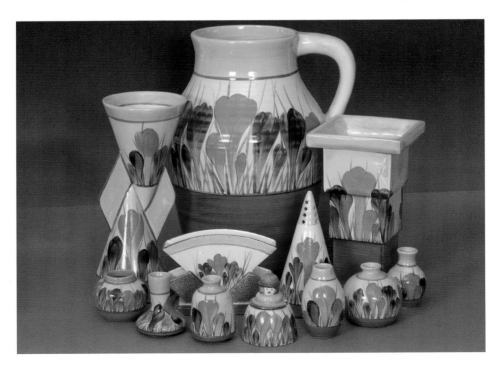

herself. She sat with three of her paintresses for press photographs, but as soon as they were taken she left with Colley. He realised that her value was as a figurehead and it did not really matter who was painting the ware, as long as the public could see it being done. The combination of Clarice's design work, Colley's business acumen and a new breed of consumer sealed the success of 'Bizarre'.

It was around this time that Clarice introduced her most famous and enduring pattern, Crocus. A simple, yet brilliant use of the paintresses' skills, the pattern involved forming clusters of flowers using single upward strokes to produce the petals; the piece would then be turned upside down for the swift addition of the leaves with a quick downward stroke. The impact of this vibrant floral pattern was instant and orders flooded in. By the beginning of 1929 demand for Crocus was so great that a separate decorating shop was established to meet the orders. Initially, Crocus was produced by just one young decorator, Ethel Barrow, who then became responsible for training young paintresses to do it. At the peak of demand, there was a dedicated team of twenty young women painting Crocus five-and-a-half days a week.

A hand-painted shape 358 vase on glaze in Pebbles, 1928.

Crocus was unusual for Clarice as it was produced on virtually everything within the range from tableware to tea wares, vases to fancies. The success of the pattern had much to do with the seemingly limitless possibilities of its application and the many variations including Purple Crocus, Blue Crocus, and Spring Crocus. Such was its popularity that it endured long after the end of the Bizarre years, even after Clarice's retirement, being painted to order by Midwinter as late as 1968.

1928 rolled effortlessly into 1929. Even more paintresses were recruited, and four 'boys' joined the Bizarre shop as outliners. By September of that year Newport Pottery had made such enormous profits that Colley Shorter decided to issue a new series of Clarice's designs under the name 'Fantasque', credited to Wilkinson's. This was a business mind in full flow as the introduction of this new name was nothing more than clever book-keeping. Whilst it was classed as part of the Wilkinson factory production for tax purposes, all the wares were still decorated at Newport. The first Fantasque range consisted of just eight patterns including some of Clarice's newly developed abstracts such as Lily, Cherry, Fruit, Pebbles and Broth.

There were now twenty-five girls and boys working in the Bizarre shop, most of them aged just fourteen, or slightly older. The Bizarre shop had a

A Tankard shape coffee service hand painted on glaze in Gayday, 1930.

A Viking boat flower vase with insert, hand painted on glaze in Gayday, 1930.

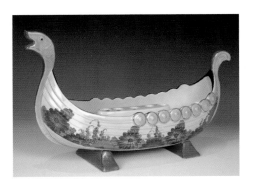

system in place with each of the decorators arranged according to their jobs. The production line began with the outliners who occupied the front benches; once the pattern was drawn it would be passed back to the enamellers who would then fill in the image with bold swathes of colour. Finally it would be passed to the banders and liners at the back, who finished the decorating process. Here they sat for five-and-a-half days a week fulfilling an ever-growing order book in return for six shillings.

Usually Clarice would assign a particular pattern to one outliner, but if a pattern became too much in demand for one outliner to manage, others were trained to do it. Over time this resulted in subtle differences in production, almost like handwriting, and patterns began to take on the character of the decorator. Sometimes when the pattern book wasn't available to check, the girls would work from memory, which also added small changes to Clarice's original concept. Such was the spirit of camaraderie within the Bizarre shop that the paintresses (who were briefly called the 'Bizarre babes') became known as the 'Bizarre girls'. With their taste for bright colours and

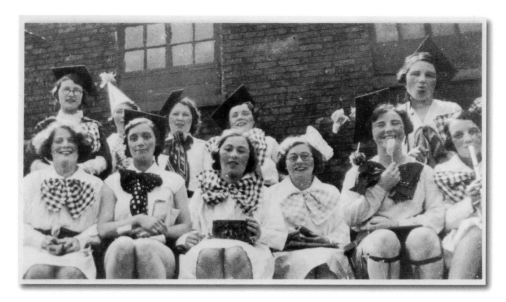

fashionable clothes they began to 'stand out' amongst other paintresses from the Potteries, and started to realise that they were part of something special.

By 1929 the vast stock of old Newport ware was running low and Clarice was busy creating new shapes more in keeping with her designs. Whilst the company already held a perfectly good stock of shapes she felt them too traditional and old fashioned to her modern style. The creation of such shapes was costly for any firm, but Clarice grabbed the opportunity to create daringly modern forms to hold her striking new patterns. She produced a range of simple but modern vases constructed from combinations of tiered circles, squares, cones and angular forms, some of which could be simply inverted to double the potential of a shape. They were sharp, and free from fussy ornamentation or handles, leaving clean open space to take Clarice's abstract patterns. During the course of the year some fifty new shapes were created, which together with an ever-growing range of patterns secured Clarice's place as the leading designer of the day.

Most significant at this time was the development of the Conical range, initially with a series of vases and bowls.

An original press photograph showing the 'Bizarre girls' in fancy dress for the 'Bizarre Skool' float for a charity parade in 1931.

A Tolphin Toilet Set hand painted on glaze in Sliced Circle, 1929.

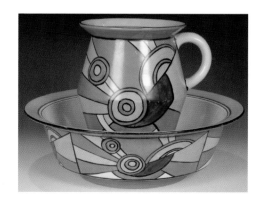

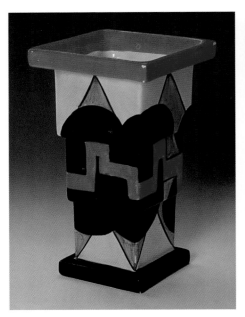

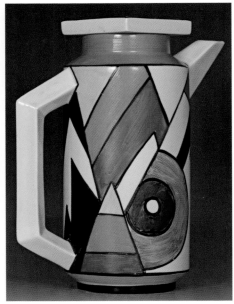

Above: A shape
369 vase hand
painted on glaze in
Castellated Circle,
1929.

Above right:
An Eaton shape
coffee pot, hand
painted on glaze in
Lightning, 1930.

The inspiration had been a silver goblet designed by the French silversmith Desny. Based on this, Clarice began evolving a series of conical forms with triangular feet or handles.

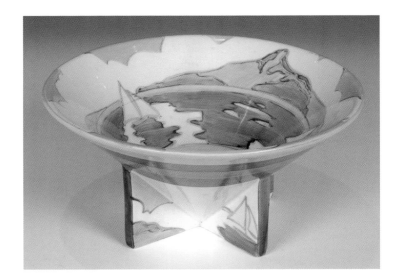

A shape 383
Conical bowl hand
painted in
Gibraltar,
1932.

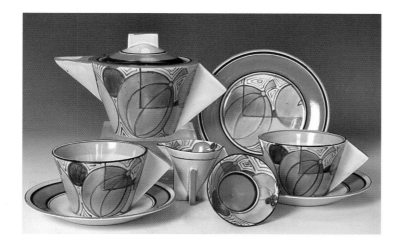

A Conical early morning tea service hand painted on glaze in Melon (green), 1930.

Clarice's developed sense of ceramic art provided her with a stubbornness that would ensure that some of her most famous designs were manufactured. Although she was highly respected by her female colleagues, the male workers on site would often fear an encounter with her, knowing that they were likely to lose. For instance, Clarice's success in pushing

A shape 360 vase hand painted on grey glazed ground in Caprice, 1928.

through her ideas caused much consternation from the senior mould maker, Bill Lunt, who was convinced that the wares were impossible to create; her determination and ability to ignore seemingly sage and sound advice caused him to utter the now famous quote 'that bloody woman'. Her belief in her designs and in the ability of the workers around her resulted in some of the most revolutionary forms in ceramic production. Without her persistence, for example, we might never have seen the Yo Yo vase with its unashamedly challenging form (see illustration, page 54). This epitomises Clarice's passion for change and her awareness of a rising new style. One can only begin to imagine what her competitors must have thought of the breadth of her creativity.

The Conical range was further developed to include tea and tableware: triangular feet were provided for the milk jugs and sugar bowls whilst the cups had solid triangular handles with

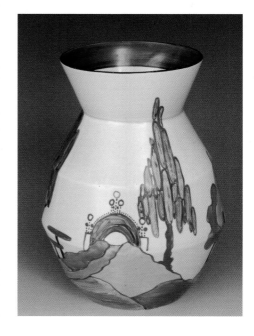

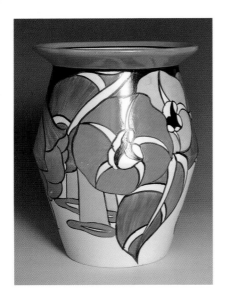

A shape 342 vase hand painted on glaze in Latona Bouquet, 1929–30.

a matching teapot. It was launched in September 1929; the modern shapes, quite unlike anything else available in the stores, proved instantly popular with young buyers and it became fashionable to give Conical sets as engagement or wedding presents. Soon, shop windows around the country were being filled with colourful displays adding to the new craze for all things 'Bizarre'. The bowl, in particular, became hugely popular and retailers such as Lawleys ordered them in their thousands.

Although Clarice had spent a number of years working with simple geometric motifs, 1929 saw the introduction of her first fantastical landscape. The original archives show a design with whimsical trees and a bridge in a mix of bold colours. Known as Caprice, it pre-dates all other abstract landscapes and stands as the foundation stone for the countless landscapes that were to follow, with elements re-appearing time and time

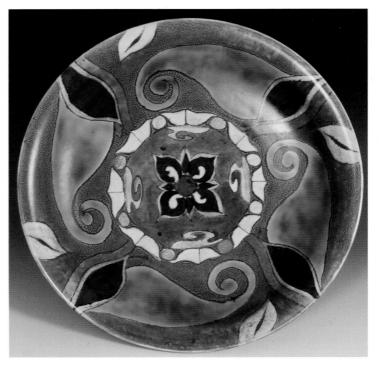

A large dish-form wall plaque hand painted on glaze in Inspiration Persian, 1929–31.

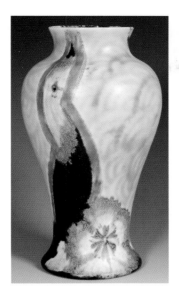
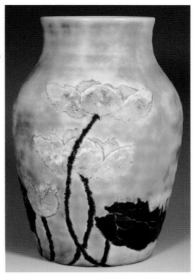

Far left: A Mei Ping vase hand painted in-glaze in Inspiration Asters, 1929–31.

Left: An Isis vase hand painted in-glaze in Inspiration Lily, 1929–31.

Below: A Mei Ping vase hand painted on glaze in Mondrian, 1929.

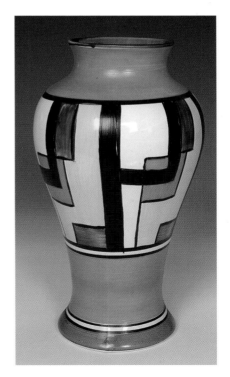

again through many of her later, more popular images. This marked the beginning of a love for quirky scenes that depicted rolling fantasy landscapes or quaint yet whimsical cottages.

Not satisfied with new patterns and shapes, Clarice also began developing experimental glazes, such as Inspiration and Latona. The latter was a milky opaque glaze that was utilised with a series of mainly bold floral patterns. It was well received, and Latona remained a popular range for two years. The Inspiration range also proved an immense success. Teamed with further promotional excellence from Colley, it was marketed as 'inspired' by the 'Ancient Egyptians', which responded to the then-current craze for all things Egyptian. The Inspiration range featured a number of landscape and floral patterns and owing to the exacting nature of the production, with the associated costs, it became the most expensive and prestigious product on the order books.

By the close of 1929 the Bizarre range had expanded to include some of Clarice's most famous designs including Sunray, Sliced Circle, Lightning, Mondrian, Blue W and Football. The whole of the

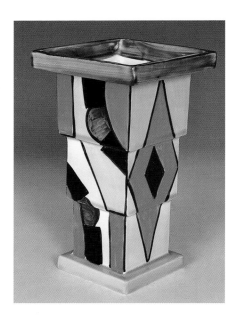

A shape 369 vase hand painted on glaze in Diamonds, 1929.

Newport Pottery was soon given over to the production of Bizarre ware and enamel kilns and ovens were manned 364 days a year to supply demand – only on Christmas Day was the factory silent! Asked in an interview at the time about her design ideas, Clarice responded that 'some weeks were better than others'; that week she had come up with only twelve new designs!

'Bizarre' painting demonstrations in stores around Britain increased and the 'girls' were thrilled to take part in these, as most had never been outside the Potteries. Mindful of their parents' concerns about their first trips away from home, Clarice ensured they were found appropriate accommodation where they would be chaperoned. The 'boys' from the decorating shop were not used for these demonstrations as Clarice thought that the image of the 'girls' was more in keeping with the image of pottery painted 'by a woman for women'.

Bizarre ware was now attracting orders from overseas. Colley Shorter had developed a good network of dealerships in most Commonwealth countries during the twenties and the larger profit margins made it a good line to export. Consignments of ware went twice yearly to major stores in

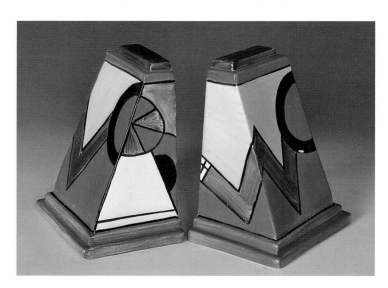

A pair of shape 405 bookends hand painted on glaze in Blue W, 1929.

North and South America, Canada, Australia, New Zealand and South Africa, including many samples and alternate experimental colourways.

Clarice, too, was developing her own promotional flair, with the creation of a series of trade displays and stands to show off her work at exhibitions. Tiered circular shelves were created for specially decorated pieces that were exhibited alongside over-sized versions of some of her most daring shapes. Exhibitions were immensely important to Clarice and every detail mattered, from the colour scheme to the arrangements. She would often spend days setting up the trade stands, fine tuning every detail to create the maximum impact. Typical of Clarice was that she would always remember the final touch – filling vases with fresh flowers just ahead of the show opening.

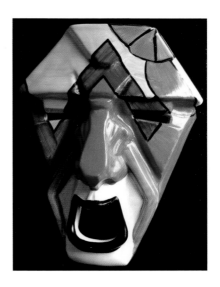

A Grotesque wall mask designed by Ron Birks, hand painted on glaze in Blue W, 1929.

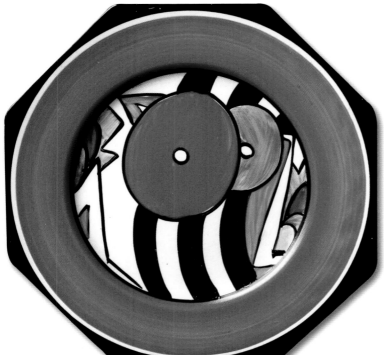

An octagonal side plate hand painted on glaze in Geometric Buttons, 1930.

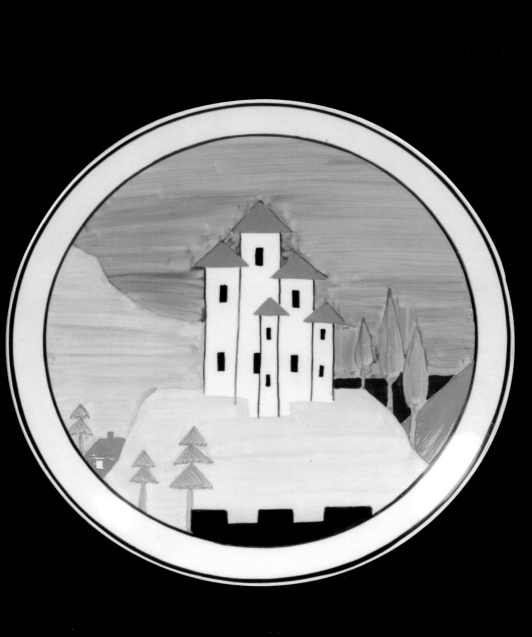

A BIZARRE WORLD

IN 1930 Clarice broke new ground once more with her appointment as Art Director to both Newport Pottery and A. J. Wilkinson. It was noted in the press of the day that she was the first woman in the Potteries to hold this prestigious role. Her new position involved spending even more time with Colley, time which gradually developed into the affair that many had suspected for years. By now, she had left her family home in Tunstall and moved to her own flat in Snow Hill, Hanley. It consisted of a lounge, bedroom, bathroom, and small kitchen with dining area. Whilst Colley was known to visit Clarice regularly, factory colleagues were rarely invited.

Clarice and Colley worked closely together on creating an awareness of Bizarre ware to catch the attention of buyers in the middle of a major financial depression. They produced a series of small colour-printed leaflets that could be obtained by post, or picked up directly from stockists. These featured a colour group illustration showing the extent of the range with a combination of vessels, plaques and tea wares together with a list of prices and an explanation of the full range. The series of leaflets, each of which covered a range of pieces in a similar style or set of colours, included ones for Bizarre, Fantasque, Delecia, Inspiration, Crocus and Gayday proved to be a very successful marketing tool.

Clarice's continued drive to produce even more fantastic patterns saw the creation of the Appliqué range. Introduced in April 1930 it was to become the second most expensive range to produce, owing to a combination of factors including the creative process, the amount of decoration and the quality and cost of the colours used. The original leaflet for Appliqué featured just two patterns, Lucerne and Lugano, but Clarice's prolific ability to design new patterns meant that by 1932 the Appliqué range had increased to fourteen, with Avignon, Windmill, Red Tree, Idyll, Palermo, Blossom, Caravan, Bird of Paradise, Etna, Garden, Eden and Monsoon. At the time, the range failed to meet with the same public approval experienced with earlier patterns – perhaps it was just too costly. By the end of the year it was all but phased out.

Opposite:
A circular dish-form wall plaque hand painted on glaze in Appliqué Lucerne (blue), 1930–4.

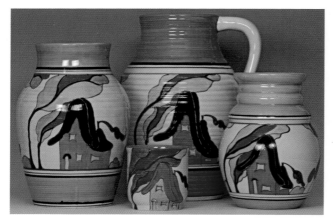

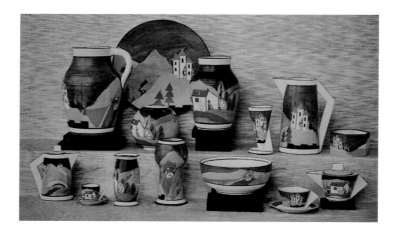

A group of wares comprising an Isis vase, single-handled Lotus jug, and shape 358 vase, all hand painted on glaze in Orange House; and a Heath Fern pot in Green House, 1930.

Above right: A single-handled Lotus jug hand painted on glaze in Delaunay, 1929.

The reverse of an original promotional leaflet advertising Clarice Cliff Appliqué wares, explaining the selection of shapes decorated in Appliqué.

Above: Pages from an original Clarice Cliff promotional leaflet, advertising Appliqué wares, showing a selection of shapes decorated in Appliqué Lucerne and Lugano, 1930–1.

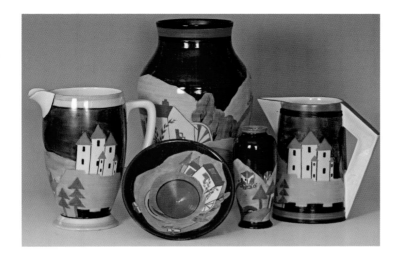

A group of wares comprising a Conical jug and Coronet jug hand painted on glaze in Appliqué Lucerne (blue), together with an Isis vase, Conical bowl and shape 186 vase, all hand painted on glaze in Appliqué Lugano, 1930–1.

In September 1930 Clarice issued what was to become one of her keynote shapes, the Stamford teapot, milk jug and sugar bowl. Based on a design by French silversmiths Tétard Frères, the teapot featured a 'D' form body with an integral curved handle and square spout that offered a perfect decorating surface for Clarice's designs. The Stamford shape was launched at the First Avenue Hotel in London, initially in her new landscape design, Trees and House, together with her latest abstract, Melon, and ever popular Crocus. This eye-catching shape proved immensely popular and customers

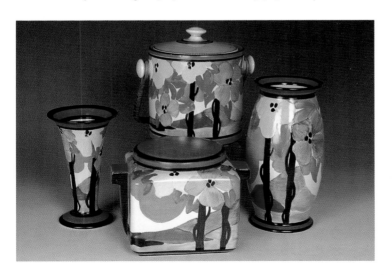

A group of wares comprising shape 278 vase, shape 422 Stamford biscuit box and cover, Hereford biscuit barrel and cover and shape 265 vase, all hand painted on glaze in Appliqué Palermo, 1930–1.

A Stamford shape
early morning tea
service hand
painted on glaze in
Appliqué Lucerne
(blue), 1930.

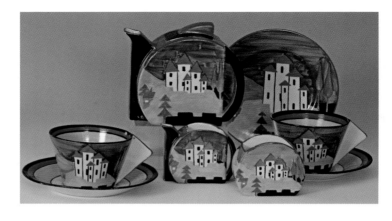

An original 1930s
advertisement
promoting Clarice
Cliff wares,
featuring a
selection of key
shapes, including a
Stamford trio and
Conical bowl,
1930.

soon ordered tea services in many of Clarice's other designs, including the bold abstracts Carpet and Tennis. But the use of the shape caused certain problems for Colley when it came to the attention of Tétard Frères, who understandably were not impressed by Clarice's unapproved use of their design. After a number of heated negotiations, an agreement was finally reached between both parties over permission to use the design.

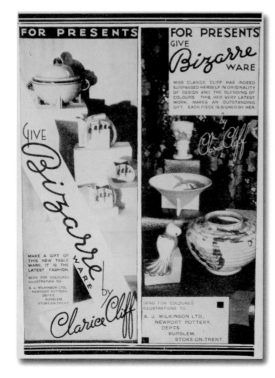

At the same exhibition Clarice unveiled her most daring ceramic creations, the five Age of Jazz figures. These were intended as table ornaments to place before the popular 'wireless' whilst listening to the latest jazz. The collection featured the flamboyant double dancers, two further couples and a group of musicians comprising drummer, saxophonist, banjo and piano players. They were a marketing dream and featured heavily throughout the press with pictures of Clarice 'painting' them heading coverage of the exhibition. Today they remain some of the most desired pieces of her massive output and continue to be elusive to collectors. Nevertheless, as she and Colley had anticipated, it was the Stamford tea ware that attracted orders; once more Clarice had perfectly judged consumer tastes.

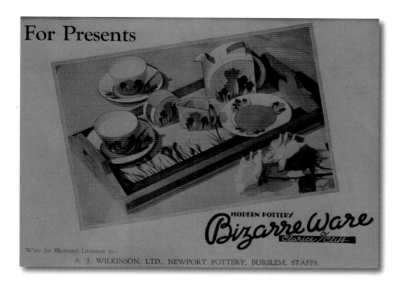

An original
marketing leaflet
promoting a
Stamford shape
early morning tea
service in Crocus,
1930–2.

In 1931 Clarice and Colley had the idea of installing a wireless in the Bizarre shop so the 'girls' could listen to music whilst they painted; again it became an instant newspaper story! The 'Bizarre girls' were pictured with the wireless, the caption reading 'These girl paintresses at the Newport Pottery works have musical interludes on the "wireless" to assist them at work. It is claimed that this original method of "working to music" has stopped talking at work and increased output by twenty-five per cent'. Whether productivity really did go up 25 per cent is irrelevant; once again they achieved a wave of publicity. Photographs of the girls working on Bizarre ware were always good for the order book and continually kept Clarice in the public eye.

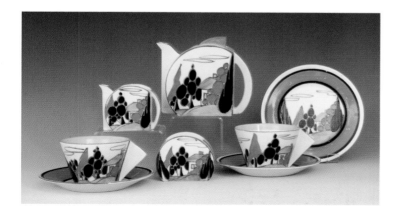

A Stamford early
morning tea
service hand
painted on glaze in
Trees and House
(orange),
1930.

Right: A single handled Lotus jug hand painted on glaze in Tennis, 1930–1.

Far right: A Clarice Cliff shape 362 vase hand painted on glaze in Sunspots, 1930–1.

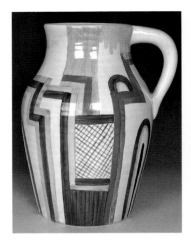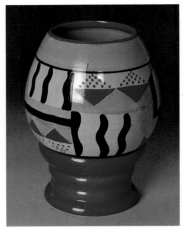

Clarice's ever-growing pattern book developed over the following months with the introduction of a number of key patterns including two of her most popular landscapes, Autumn and Summerhouse, together with a selection of stylish yet simple fruit patterns including Oranges, Apples, and Oranges and Lemons. As these became the new mainstay of the order books, older patterns that had started to wane in popularity were either retired or re-invented. The sales of Inspiration wares were declining so the technique was adapted for a new pattern, Marigold, which featured the fluid tonal blue hues as a background that was then over-painted on glaze with large blooms.

An original promotional photograph displaying a Stamford early morning tea service on an associated tray, lithograph printed and hand painted in Solomons Seal, 1930.

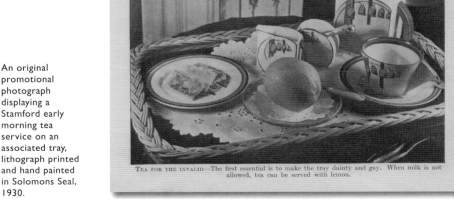

TEA FOR THE INVALID—The first essential is to make the tray dainty and gay. When milk is not allowed, tea can be served with lemon.

34

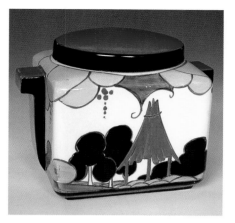

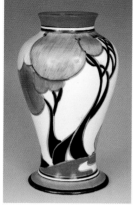

Far left: A shape 422 Stamford biscuit box and cover hand painted on glaze in Summerhouse, 1931.

Left: A Mei Ping vase hand painted on glaze in Autumn (blue), 1930.

A group of Clarice Cliff wares comprising a Stamford teapot, milk jug and sugar bowl, small beaker and shape 515 flower vase, all hand painted on glaze in House and Bridge, 1932.

This process was also used for a range of wares called Clouvre. Neither sold well, and so they are sought-after rarities now. Before the year ended, she introduced Red Roofs, Farmhouse, House and Bridge, and the dramatically different Gibraltar patterns to the public. The unusual Gibraltar seascape

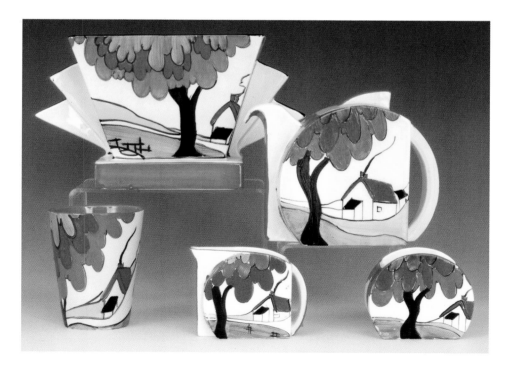

Right: A shape 14 vase hand painted on glaze in Floreat, 1930.

Far right: A Leda shape plate hand painted on glaze in Apples, 1931.

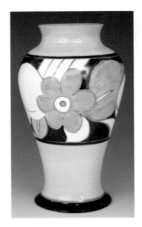

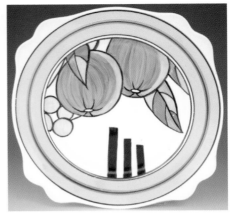

A single-handled Lotus jug hand painted on glaze in Oranges and Lemons, 1931.

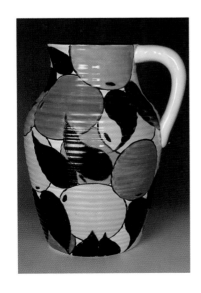

used only pastel shades of pink, pale green, blue and yellow with none of Clarice's favourite orange in sight. Essentially a more feminine colourway, it proved popular with buyers and sold well. Even when the vivid geometric and landscape designs were best-sellers, Clarice still created modelled or textured wares, such as Patina, with its slip-decorated surface, and the deeply embossed Marguerite and Scraphito ranges, adding even greater diversity to her already large range of wares.

Orders flooded in for the new shapes and patterns and Clarice was forced to take on even more staff including her own sister, Ethel, whom she employed as a bander and liner. Shapes continued to interest Clarice and throughout 1931 she introduced a number of fancies ranging from novelty figures, such as the Lido ashtray, to one of her most enduring shapes, the Conical sugar sifter. Launched in August 1931, the Conical sifter proved an instant success. The idea had been 'on paper' for some years, so it remains somewhat of a mystery why Clarice waited so long to bring it to the market. Also the late arrival of such an iconic shape meant that many of her greatest abstract patterns would never be teamed with this simple yet effective design.

With seemingly boundless imagination Clarice continued to develop new ways to promote her wares, creating a 6-foot high pottery horse constructed from many of her shapes, decorated in the very latest patterns. The figure of a man was the jockey, and there was also a large stylised tree, the foliage being a mass of plates! The figures were then loaned to the 1931 'Crazy Day Parade' on

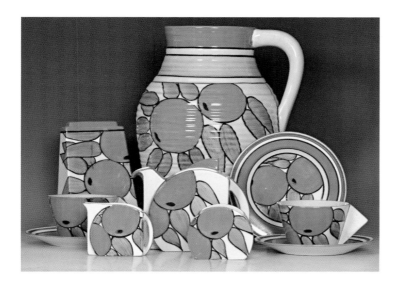

A group of wares comprising shape 405 bookend, single-handled Lotus jug and Stamford shape early morning tea service, all hand painted on glaze in Oranges, 1931.

board the Newport Pottery float and the 'Bizarre girls' all dressed up as jockeys and ran alongside the float. Yet again press and publicity followed, with further coverage throughout the popular press. They were then loaned to major retailers to form the centrepiece for window or floor displays and promotional events.

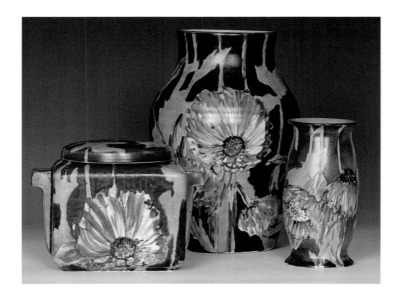

A group of wares comprising shape 422 Stamford biscuit box and cover, Isis vase and shape 264 vase, all hand painted on Inspiration ground in Marigold, 1931.

A shape 489 Conical sugar sifter hand painted on glaze in Berries, 1931.

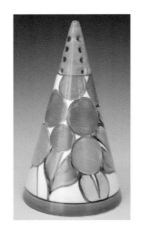

An original press photograph showing a window display for Havens Store, Southend-on-Sea, featuring the Bizooka horse, jockey and tree, 1931.

Clarice's widespread international fame was quite astonishing for this still rather camera-shy woman. The publicity she received in the press was unprecedented; time and again, Clarice featured in articles around the world. In the *Californian Pasadena Evening Post*, Clarice is pictured standing with her Bizooka pottery horse. In the feature she offers what has become one of her most famous and enduring quotes: 'Having a little fun at my work does not make me any less of an artist, and people who appreciate truly beautiful and original creations in pottery are not frightened by innocent tomfoolery.'

December 1931 saw the culmination of many hours' promotion and endless successful marketing campaigns when *The Daily Sketch* featured a full page dedicated to Clarice Cliff and her work. The Bizarre shop was photographed and featured below a headline that read, 'How famous Bizarre ware is made at Stoke'. Colley ordered up a thousand

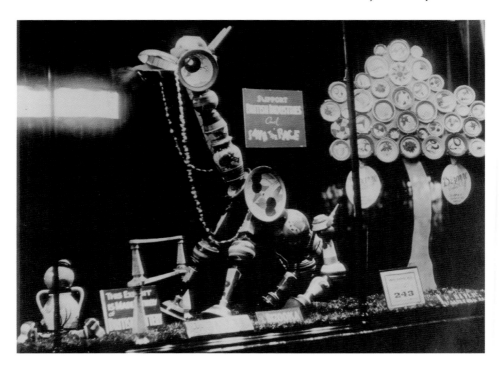

copies of the paper and ensured that every retail outlet in the country received a copy. Again pure publicity genius! Clarice's foremost position in the pottery industry was undeniable; she was, without question, at the pinnacle of her career.

In 1932 the Prince of Wales gave a speech challenging British industry to 'raise the standard of design in its products' which he believed were not innovative enough to compete with foreign imports. The simultaneous publication of the Gorell Committee's Report on Art and Education meant that many industries where design was essential were drawn into a project linking them with well-known artists of the day. The Society

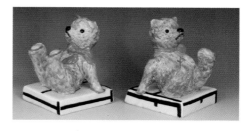

A pair of shape 407 novelty Teddy Bear bookends hand painted on glaze in orange and green with black monogram bases, 1933.

An original 1930s press photograph featuring Clarice Cliff standing in front of her Bizooka horse and Fantasque tree, 1931.

A Stamford
bachelor tea
service hand
painted on glaze in
Canterbury Bells,
1932.

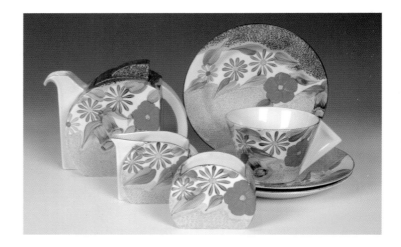

of Industrial Artists issued a list of designers for the project and Clarice read through this, noting the names of Vanessa Bell, John Armstrong and Paul Nash. Possibly she did not realise the immensity of the task ahead of her. She had to liaise with all the artists whose brief was to produce innovative patterns for tableware. The result was that Clarice suddenly had little time to dedicate to her own work.

The first wave of 'Artists in Industry' pieces was debuted in the summer of 1933 at the British Industrial Art in Relation to the Home exhibition, at Dorland Hall, London. A negative response from critics and public alike

A shape 467
smoker's set hand
painted on glaze in
Blue Chintz,
1932.

forced a re-appraisal. Colley Shorter was consulted on a further choice of artists and by 1934 nearly thirty new leading names were involved. The list represented some of the greatest British artists of the day including Graham Sutherland, Duncan Grant, Frank Brangwyn, Barbara Hepworth, Ben Nicholson and Laura Knight.

Socially Clarice had little in common with these artists, but in one, Laura Knight, she found a true friend. Laura Knight was as colourful a character as Clarice and shared an unorthodox approach to art. To capture the colour of the circus for her oil paintings, Laura had lived and toured with Carmo's Circus; these works provided the inspiration for her designs, Circus tableware. This included modelled shapes that appealed to Clarice, as they were more refined versions of the figurines she had made in the twenties. A candlestick was formed from two chubby clowns seated back to back, and a tureen handle was a clown doing the splits! The pinnacle of the collection, however, was a lamp base that featured clowns and acrobats in a daring feat of performance, stacked one on top of each other to produce the column.

The pressures of working on the project led to disagreements between Clarice and Colley as her heart was not truly in it. Despite the government impetus and touring exhibitions throughout 1934, 'Artists in Industry' was deemed a failure. 'Bizarre' shapes without 'Bizarre' patterns did not tempt the public to pay higher prices.

A Laura Knight 'Circus ware' side plate; a printed, colour lithograph with hand painted enamelling.

The British Industries Fair was Clarice's first major trade show of 1933, and as always was visited by the King and Queen. They were keen to support industry during the Depression and Queen Mary generally chose a few pieces of Crocus each year to add to her collection, avoiding the bolder Bizarre designs! Naturally Clarice had created another new shape – an innovative teapot that she called Bon Jour. Circular and flat-sided, with a simple round finial, it was a natural progression from the Stamford. Bon Jour quickly established itself as Clarice's most popular teapot, and, in turn, inspired a whole new line in tableware, which she

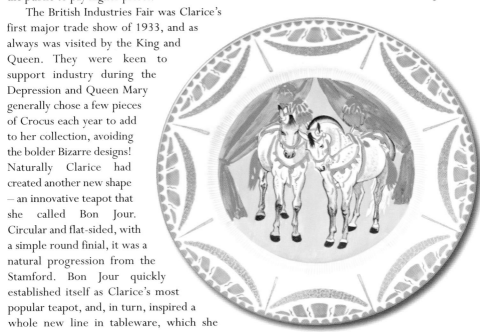

A single-handled
Lotus jug hand
painted on glaze in
Windbells, 1933.

called Biarritz. This incorporated elements from a variety of her existing shapes; plates were square or oblong, whilst tureens were semi-circular and flat-sided with oblong lids. Bon Jour looked stunning in Clarice's new 1933 landscapes. Secrets, Rudyard, Honolulu and Solitude all went on to become popular sellers, but possibly her most significant pattern of this year was the newly introduced May Avenue.

Named after a place only a few streets away from her Tunstall home, May Avenue featured a row of red-roofed houses nestled amongst spade-shaped trees and blue bushes with a large two-tone tree to the foreground. This design is believed to have been inspired by 'Landscape at Cagnes' by Modigliani and again shows how aware Clarice was of the larger art movements in Europe. It also used new decorating techniques where the design was drawn with a pen rather than being outlined by a paintbrush. This allowed for a greater level of detail and a finer final image. Although sales were somewhat limited at the time, this pattern has gone on to become one of the most admired, loved and sought-after landscapes of Clarice's phenomenal output.

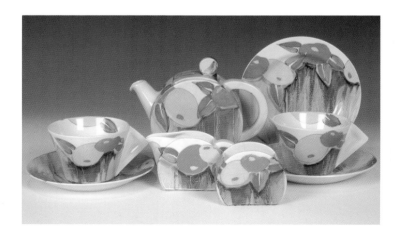

A Bon Jour shape
early morning tea
service hand
painted on glaze in
Delecia Citrus,
1933.

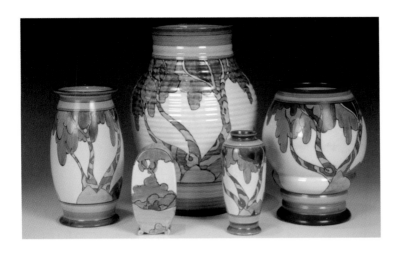

A group of wares comprising shape 265 vase, Bon Jour sugar sifter, Isis vase, shape 186 vase and shape 362 vase, all hand painted on glaze in Rudyard, 1933.

Other key patterns followed and Clarice added Coral Firs, Blue Firs and Bridgwater, together with shapes such as Lynton, filling the pattern books with even more options. In 1934 Clarice reverted to her first love, modelling, and produced the My Garden range. It debuted at the *Daily Mail* Ideal Home Exhibition in July and proved popular for the rest of the decade with numerous variations being issued annually. Whilst the success of My Garden

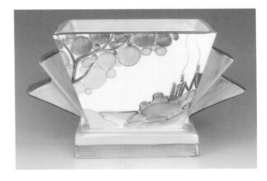

Above: A shape 515 flower vase hand painted on glaze in Secrets, 1933.

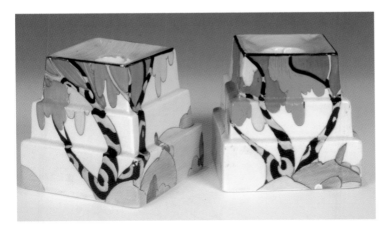

A pair of shape 391 Ziggurat candlesticks hand painted on glaze in Honolulu pattern, 1933.

A large circular ribbed charger hand painted on glaze in May Avenue, 1933.

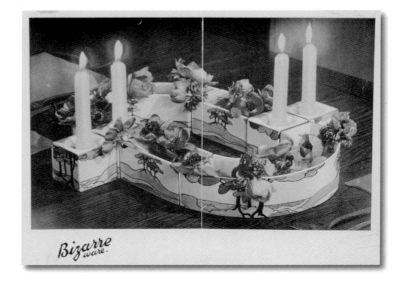

Above: A Bon Jour shape sugar sifter hand painted on glaze in Coral Firs 1933.

An original Clarice Cliff promotional leaflet for the 'As you like it' table centre featuring an arrangement decorated in Blue Firs, 1933.

Bizarre ware.

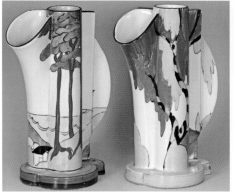 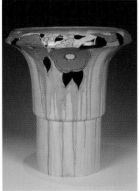

Left: Two Clarice Cliff shape 469 'Liner vases', each hand painted on glaze in Coral Firs and Honolulu, 1933.

Right: A shape 375 Archaic vase hand painted on glaze in Lydiat, 1933.

grew, so the more daring patterns of earlier years were beginning to fade in favour of more conservative styles. There were a number of 'genius moments', however, with the development of the Bon Jour series of vases, whilst her Yo Yo vases saw subtle alterations, bringing them back to the forefront of the order books.

A further key development arising from Clarice's endless inventive design flair was the introduction of yet another new style in decoration – etched brushstrokes. In complete contrast to the brash and bold application of colour seen in earlier Bizarre wares this had colours gently blended together, creating a softer finish. Applied in a freehand manner without

A group of My Garden range wares comprising two shape 677 flower jugs, a shape 670 flower vase and a circular footed bowl, all relief moulded with stylised flowers on glaze decoration, 1934.

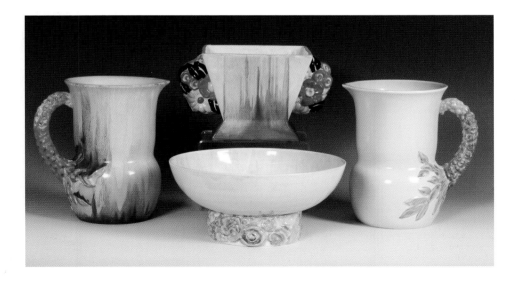

A Bon Jour range Tyrol shape bowl, hand painted on glaze in Rhodanthe, 1934.

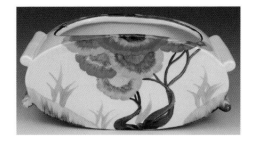

outlining, it became most successful with the introduction of the Rhodanthe pattern. Rhodanthe became one of Clarice's last great stylised florals. Although a lifetime away from the striking geometrics of just four years earlier, it sold in fantastic quantities and was applied to every conceivable item within the pattern range, just like Crocus.

By 1935 there was a definite change in the mood and character not only of Clarice herself but also of her work. Whether this was a response to the previous year's difficulties or to the market remains unclear, but throughout 1935 many things began to alter. Whilst the more recent landscapes such as Coral and Blue Firs remained popular, the earlier brighter wares were becoming less in demand. The consumers were leaning towards a softer palette and a more natural style of modelling.

An original photograph showing the 'Bizarre babes' float in the 'Crazy Day' parade of 1935 celebrating the jubilee of King George V, raising funds for local hospitals.

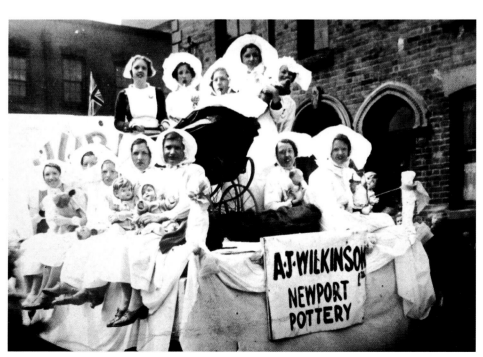

Clarice, always one to listen to her audience, moved towards increasing the My Garden range and, as she had done earlier, expanded the range of patterns with the introduction of numerous colour variations of key designs such as Rhodanthe.

By this time, 'Bizarre' was beginning to draw to a natural close. The many original shapes and patterns Clarice had created were phased out and the buyers were seemingly beginning to turn to a different style. A number of Clarice's favourite paintresses left to start families whilst some key outliners left for higher paid jobs.

In response to a shrinking home market, a major export drive was mounted and Clarice continued to be popular with overseas buyers. Colley Shorter's foreign dealers distributed Clarice's pottery to many corners of the globe despite a deepening worldwide Depression and Clarice developed a more rational if somewhat cautious style to her production. She herself was heading towards her thirty-seventh birthday which by the standards of those around her at the time was middle aged. A new mature expression developed in Clarice's work and with it a new wave of patterns, shapes and, more importantly, sales.

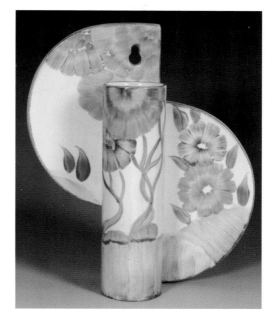

A shape 465 wall pocket hand painted on glaze in Pink Pearls, 1934.

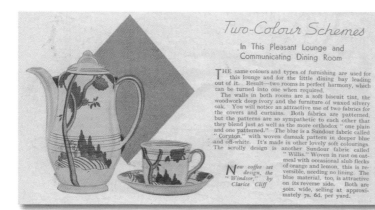

An original promotional advertisement from *Modern Home*, displaying a Clarice Cliff Windsor shape coffee service in Mowcop, October 1938.

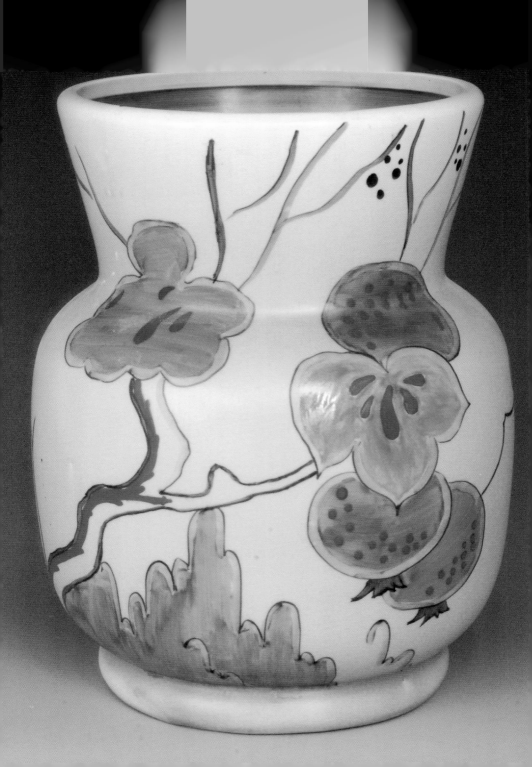

THE END OF AN ERA

THE DEATH of King George V on 20 January 1936, followed by the looming threat of war, was to set the mood in Britain for the rest of the decade. Clarice's response to this was that her ceramics gradually moved towards a more subdued palette and more traditional shapes. The sombre and uncertain mood was further compounded with the affair of Edward VIII and American divorcee Mrs Simpson. The appetite for 'Bizarre' had all but disappeared, and with it went the name. 'Bizarre' was dropped from the back stamp and replaced with a simple yet enlarged version of Clarice's own signature. One last magical landscape straddled this transition, Forest Glen. A classic combination of a Clarice Cliff cottage nestled amongst stylised bushes but set below an oppressive tonal red streaked sky, it represented a final flourish of confident genius.

By 1936 Clarice was in a unique position, as Art Director of two factories, her name stamped on tableware and vases all over Britain and the Commonwealth. Indeed, Colley Shorter had commented the previous year that her role 'had begun in a small way and resulted in one of the biggest jobs of its kind in Great Britain'. Today, collectors distinguish between her ware before and after the '1936 watershed', but Clarice's commercial success was totally consistent throughout the 1930s.

Clarice's designs now took on a softer palette with more sparsely applied decoration. Indeed, they were now more safely 'British' than the racy Art Deco and European influenced pieces born of Bizarre ware. There were no abstracts, whilst landscapes became subtler and floral patterns less daring. The wares were more homely and conservative with many simple relief moulded designs decorated in more muted shades. Endless variations on the My Garden theme were to appear annually, to satisfy a huge demand. A My Garden vase might not have been as exciting as a YoYo vase, but it was what the buyer now wanted, and Clarice was geared up to produce such ware in great quantities for customers. The glazes on the ware changed too. Clarice's Honeyglaze was replaced with a new range of soft colour shades, including a celadon green and mushroom. 1938 saw the introduction of yet more

Opposite:
A shape 779 vase hand painted on glaze in Passion Fruit, 1936.

A shape 450
Daffodil bowl hand
painted on glaze in
Forest Glen, 1935.

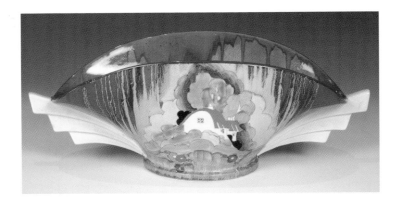

modelled shapes including the Water Lily range and the incredibly popular
Celtic Harvest. Tableware decoration was predominantly simple banded
colours or partial shoulder patterns and the trend for naming patterns was
replaced with the use of numerical codes.

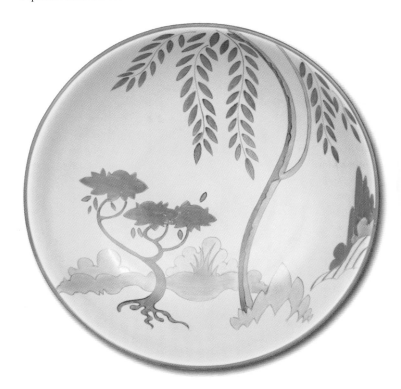

A footed circular
fruit bowl hand
painted on glaze in
a variation of
Mowcop, 1937.

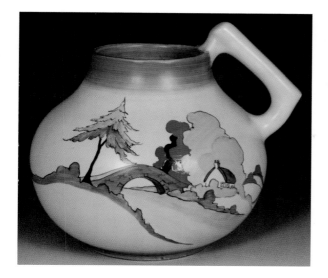

Whilst the sales ledgers still showed orders for some of Clarice's earlier landscapes, the production levels of the relief decorated pieces were beginning to overtake the hand-painted ranges and slowly the need for the variety of decorating skills diminished. By 1939 there were just forty girls left in the decorating shops, a significant drop from only a few years earlier, when the benches had rung out to the giggles and chatter of over one hundred decorators. The announcement of war on 3 September 1939 caused production to switch swiftly to the manufacture of table, hotel, utility and military ware. Over the following months more decorators left to join the war effort in munitions or the forces, and Clarice was left with just a skeleton staff.

November 1939 saw a development that would impact on Clarice's life far beyond the stresses of the day-to-day running of the factory. Colley's wife, Annie, died in hospital following a lengthy illness. There was a quiet funeral and almost immediately Clarice and Colley became inseparable. Whilst few commented, many knew of their affection for each other. At the time a close friend of Colley's was known to have commented, 'It's about time you married that girl'. Public opinion of the time held it entirely inappropriate even to consider remarrying so soon after the death of one's wife. However Colley, not one to adhere to common practice, asked Clarice to marry him. On 21 December 1940 they wed in secret, to the knowledge of only a few family members and close friends.

Above: A shape 613 vase hand painted on glaze in Silver Birch, 1937.

Above left: A shape 634 jug, hand painted on glaze in Lorna, 1936.

Two single-handled Lotus jugs both hand painted on glaze in Blue Chintz, 1932.

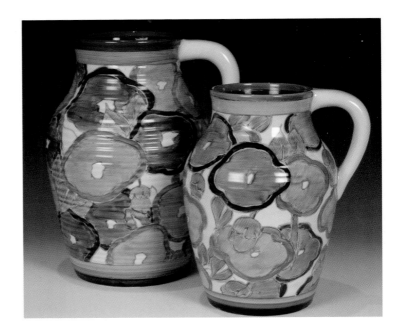

During the war years Clarice found she was rarely at the factory but was more involved with the running of Chetwynd House. It had been Colley's home for many years, and was a significant property in the district. Designed in 1899 by Parker and Unwin, and standing in over 6 acres of grounds, Chetwynd was an important example of Arts & Crafts architecture. Her love of the garden became so intense that Clarice spent virtually all her days tending the flower beds and creating the perfect interpretation of an English cottage garden.

Meanwhile, the factory had to conform to strict wartime restrictions; production of hand-painted wares all but ceased, with the output down to the production of just a few girls. By 1942 the last few staff had been integrated into the A. J. Wilkinson site whilst the Newport Pottery was taken over by the War Office, never to re-open.

After the war, although Clarice was occasionally nostalgic for the 'Bizarre years', she seemed realistic as to the new post-war consumer taste and accepted the change in preferences in which she was not to play a significant part. Indeed Clarice seemed to enjoy playing a lesser role at the factory, knowing that she could not recapture those crazy days of the 1930s, whilst Colley spent time overseas trying to stimulate sales. In the autumn of 1949 he and Clarice went to Canada and the United States, giving interviews and taking orders. Much of the post-war production went to North and South

America, Canada, Australia or New Zealand, where the taste was for formal ware in traditional English designs rather than the striking Bizarre patterns and shapes that had made Clarice so famous.

The factory continued to prosper, and the introduction of modern new equipment pushed the need for hand work even further into the past. Colley Shorter undertook a full programme of modernisation, installing the latest gas-fired continuous ovens, and Clarice and Colley suddenly found that they had more time on their hands and for each other. 1952 saw the re-introduction of a small hand-painting studio and Clarice contacted some of her original 'Bizarre girls'. Work resumed, but only on a small scale. Crocus continued to be popular and later patterns such as Rhodanthe were revived, but the post-war restrictions in the lead content of the on-glaze enamel colours meant the pottery lacked the striking vibrancy it had previously possessed.

Whilst Clarice loved the Potteries she soon realised that she loved her husband more. More time was spent away from the factory indulging in exotic around-the-world trips, meeting overseas agents, and catching up with family. A few final attempts were made at developing new designs, but the introduction of a thirty per cent tax on home wares put an end to any desire to re-enter the domestic market. Overseas, the best seller was the traditional Staffordshire Tonquin, a transfer-printed oriental scene which sold thousands of pieces each week.

An original promotional advertisement from *Modern Home*, displaying a Bon Jour shape early morning tea service decorated in 8 O'Clock ware, December 1934.

In 1963 Colley passed away, and without him neither the factory nor Clarice could continue. An approach was made by Roy Midwinter of Midwinter Pottery to purchase the whole works and Clarice accepted. Subsequently she became somewhat of a recluse, preferring to stay at home tending the garden she loved so much.

Just a few years later, new interest in her former 'Bizarre' work was beginning to grow, although Clarice modestly sought to ignore this enthusiasm. She was first acknowledged as a leading designer of the inter-war years by the Minneapolis Institute of Arts in 1971, when a large selection of her wares was featured in the World of Art Deco exhibition. This was closely followed by an exhibition solely of Clarice's work at the Brighton Museum and Art Gallery between January and February 1972. Clarice reluctantly agreed to provide comments and information for the catalogue, though she refused an invitation to attend the opening and only told her family of the exhibition after it had closed. It was to be her last contact with the 'Bizarre years'.

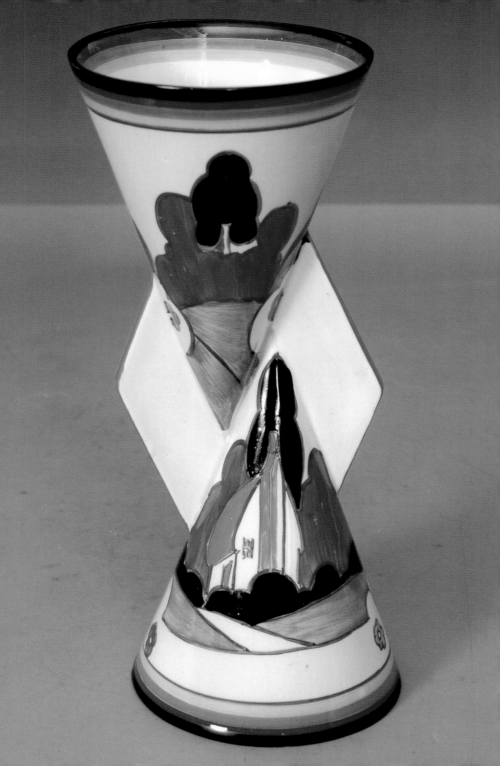

INSPIRATION AND INFLUENCES

ALTHOUGH Clarice Cliff's influences were many and varied, it is clear that some of the main sources of inspiration for her work were from London and Europe. The 1925 'Exposition des Arts Décoratifs et Industrial' in Paris launched a new era in design and style. The florid motifs and whiplash lines of the Art Nouveau and Arts & Crafts movements were swept away in favour of abstraction, angularity, bold colours and dramatic new forms. Whilst these motifs and ideas took some time to filter across to the more sedate world of the Potteries, Clarice's character and passion for design ensured she was at the forefront of fashion and taste.

Clarice's brief secret trip to Paris with Colley Shorter fed her love of modernism and flooded her senses with styles, colours and forms. The influence of Cubism, Orphism, Abstraction and other key movements were manifested in her work for years to come. In some cases, direct reference can be made to a specific designer, artist or a particular painting. This, together with her brief placement at London's Royal College of Art in 1927, combined to instil in her the seeds of an exciting new style for pottery far removed from the more sombre ceramics Staffordshire produced at this time.

In London and Paris, Clarice was exposed to a dazzling array of fashionable shops and even more fashionable shoppers, art galleries, museums and exhibitions. During her time in London she is known to have visited an exhibition of 'Modern French and Russian Designs for Costume and Scenery' held at the Victoria and Albert Museum. The exhibition offered illustrations and designs by Georges Braque, Leon Bakst and Pablo Picasso: a riot of colour and form shown in a swirl of fantasy with stylised landscapes, oversized blooms, trees and houses, all of which would appear in Clarice's own work. Furthermore, the London museums offered access to hundreds of other items from civilisations old and new, from Greek vases to Egyptian masks, providing her with countless influences rarely incorporated into Staffordshire ceramics.

Clarice's thirst for new and fresh ideas in design was supported by her increasing and carefully selected library, stored in a locked cabinet in her

Opposite:
A shape 379 Yo Yo vase hand painted on glaze in Farmhouse, 1931.

The cover to Eduard Benedictus's folio of designs *Nouvelles Variations – Soixante-Quinze Motifs Décoratifs en Vingt Planches par Benedictus*, formerly the property of Clarice Cliff, 1927.

A pair of shape 279 vases hand painted on glaze in Sunburst, 1930.

studio at Newport. Assembled from 1927 onwards, it marked the start of a period of tremendous personal artistic growth and productivity. It comprised various significant books, journals, and folios on decoration and design, none more important to her than the collection of works by leading French designer Eduard Benedictus.

Benedictus was an industrial artist and designer who created folios of custom-printed artwork, using the pochoir process. This enabled the use of vivid colours, and was intended for fabrics, wallpaper or other interior decorative uses. The folios were filled with groups of designs depicting floral, landscape or abstract motifs in bright modern colours. Clarice saw in them a rich vein of ideas that would translate beautifully onto her wares. From her extensive output of over 270 designs in the 'Bizarre years' there are several that may be seen as copies, for example Appliqué Lucerne, Sharks Teeth and Butterfly. In essence, however, Clarice only borrowed parts of the designs rather than plagiarised the whole image, which often provided a starting point from which her own signature design would emerge.

Similarly the work of Eric Bagge was to provide the inspiration for one of Clarice's best loved early abstracts. In 1929 Bagge created a design for a textile rug with a series of curved lines and dots, shown in an issue of *Mobilier et Décoration*. It was in monochrome so the stylish black, grey and red palette was Clarice's own.

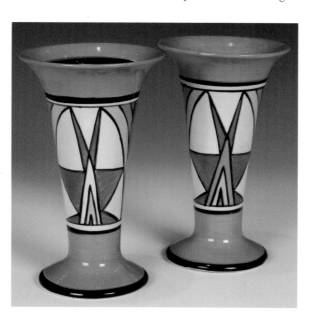

As her original pattern name is lost, it naturally became known as Carpet.

A further striking abstract in similar colours was produced, and is now entitled Café. Its simple repeat of grey, black and red panels with contrasting red dots is believed to have been inspired by a daring 1928 interior scheme for the Café de l'Aubette in Strasbourg, designed by Swiss-born Sophie Taeuber-Arp in collaboration with Theo van Doesburg. If this was the starting point for Clarice's interpretation, it once more shows a designer firmly in tune with the rise of international decorative arts.

Whilst some of her French-inspired shapes were intrinsically copies, Clarice clearly had a gift for turning the concept into a full range. There had long been a tradition of cross-over between the silver and ceramic arts, and many of Clarice's greatest forms owe a debt to leading silversmiths of the period. Clarice regularly took journals such as *Mobilier et Décoration* which gave her source material from the world's leading designers.

An original pochoir print design by Eduard Benedictus from the folio of designs *Nouvelles Variations – Soixante-Quinze Motifs Décoratifs en Vingt Planches par Benedictus,* formerly the property of Clarice Cliff, 1927.

The magazine showcased the latest designs in all mediums and Clarice is known to have used a number of pieces for key ranges in her work, most notably the Stamford and Conical shape ware.

The Stamford shapes were a direct copy of a design by French silversmiths Tétard Frères, which had been created for the French actor Jean Richepain, and had won a medal at the 1925 Paris exhibition. The tea set had been featured in *Mobilier et Décoration* where conveniently one picture showed the teapot from two different angles. This allowed Clarice to understand perfectly the form and proportions enabling her to re-create it accurately. But

it was ironic that in the five intervening years no-one else saw its appeal to a mass market, and that it took a designer from Stoke-on-Trent to realise that potential.

Whilst Clarice may have directly copied to create the Stamford teapot, the Conical series was an example of her skill in taking an idea and not only developing it but ultimately improving it.

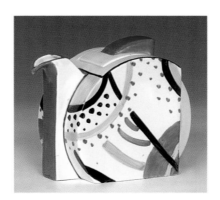

A Stamford shape teapot and cover hand painted on glaze in Carpet (red), 1930.

Right: A Mei Ping vase and a pair of 391 Ziggurat candlesticks, all hand painted on glaze in Café, 1931.

Below: A Stamford shape teapot hand painted on glaze in Appliqué Windmill, 1930–1.

Bottom: A shape 380 double Conical bowl hand painted on glaze in Mondrian, 1929.

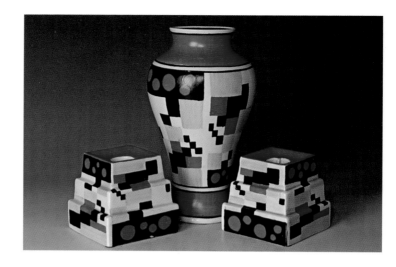

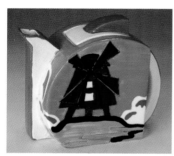

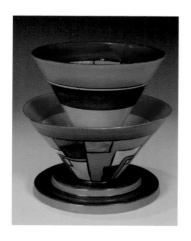

Clarice had seen a silver cocktail service created by Desny around 1926–8. This featured a large cone on top of a smaller one with a thin metal supporting blade between them. From this, in just a few months of 1929, Clarice created a range of daringly modern forms that included the popular Conical teapot, the Double Decker vase (one cone inside another), cups with triangular handles, bowls in many sizes, and (perhaps) her most breathtaking piece, the Yo Yo vase. In 1931 she belatedly completed the range with the stylish and now much sought-after Conical sugar sifter.

The years spent absorbing the technical processes of the Potteries had taught Clarice vital lessons regarding form, construction and viability. For example, the Yo Yo featured strong yet elegant supporting blades that, whilst decorative, prevented the whole piece collapsing when fired in the kiln. The shape remains one of the most desired forms she ever created. Introduced at the height of the Depression, it would appear that sales were limited, though for Clarice it was such a favourite that over several years a number of oversized, giant versions were created to use as centrepieces for her trade shows.

Other famous Clarice forms may be traced to European designers, such as the simple globe vase (shape 370), clearly inspired by the work of French designer Robert Lallemant,

and the shape 463 cigarette holder that is instantly recognisable as a copy of a glass and metal version created by the Austrian Josef Hoffmann.

It took several writers and twenty years' worth of books on Clarice Cliff to find the sources I have listed. Today some of the original designers remain obscure, whilst she is again a household name. This demonstrates how wisely and widely she delved into low-circulation little-known magazines in search of inspiration. And most importantly it has to be said that there are hundreds of shapes and designs that show no outside influences; many of her countless landscapes and bold florals owe nothing to anyone, they are pure Clarice. The fact that Clarice left the journals and folios at the factory when she retired shows that she did not intend to make a secret of using them. They proved to be an important reference source throughout the key years, keeping her informed of the ever-changing fashions. What may be deduced is that Clarice was a designer of her time. In the same way that art and design has always influenced itself and always will, so Clarice allowed herself to become part of the vogue. The fact that she was in Stoke-on-Trent and not London, Paris, Switzerland or Austria makes her achievements even more startling. She captured the mood of the times and transferred it onto wares that would be popular with her customers.

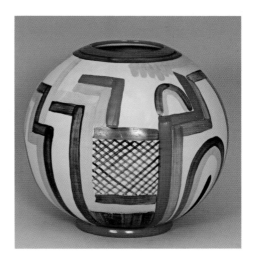

A shape 370 vase hand painted on glaze in Tennis, 1930-1.

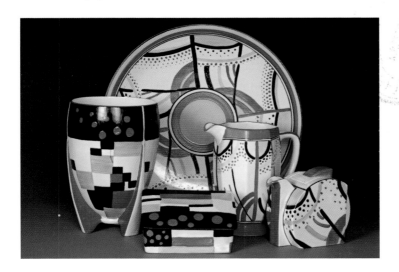

A group of wares comprising shape 452 vase and cigarette box hand painted on glaze in Café pattern, 1931, together with a large dish form circular wall plaque, Athens jug and Stamford teapot, all hand painted on glaze in Carpet (red), 1930.

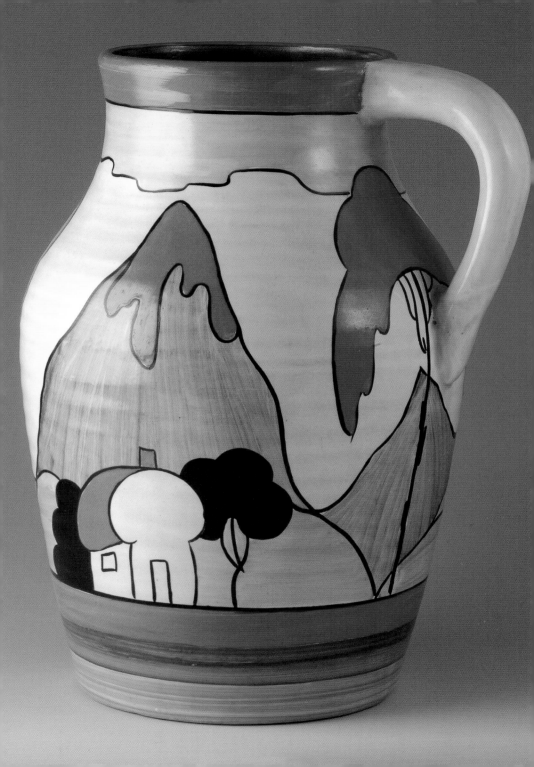

CLARICE IN CONTEXT

FOR A POTTERY apprentice from Stoke-on-Trent to achieve what Clarice did is quite remarkable, particularly when put into the context of the period, environment and opportunities. Clarice became a unique designer who sought inspiration from worldwide influences her contemporaries were either completely unaware of, or ignored. When assessing her sources and influences we can distinguish between those that had a profound influence and those that were merely a catalyst for an inspired thought.

Clarice Cliff's aim was to reject the Victorian style that dominated the Potteries, and in doing so she created an immense catalogue of shapes and patterns. It is impossible to count accurately the number of shapes and variants she produced, but in just four key years she amassed 220 shape numbers, and at least eight named tea and coffee ranges – in fact Clarice had designed around 300 shapes! Combine this with the 270 plus patterns and it becomes understandable, if no less astonishing, to see how she is credited with producing some 8.5 million pieces during her career.

No other Staffordshire pottery designer came anywhere close to equalling Clarice Cliff's prolific output between 1927 and 1936, because no one else was in charge of designing both shapes and patterns. If Clarice had only designed the shapes and fancies she dreamt up, she would undoubtedly have made her mark on ceramic history, but the fact was, of course, that she combined them with innovative, colourful designs!

Clarice achieved her spectacular output with the help of the very skilled staff at her factories, and the complete faith of Colley Shorter in her ability to help Newport and Wilkinson's survive the Depression. Clarice's gift was in creating shapes that no one else dared to attempt to make, and then decorating them with equally daring designs. All the evidence shows that she was *the* most influential British designer of the 1930s.

In October 1972 Clarice passed away peacefully at Chetwynd House. She would certainly have been amazed that within only ten years a collectors' club devoted solely to her work was founded. And it was just seven years after this, that as a fourteen-year-old 'fan' of Clarice and 'Bizarre'

Opposite:
A single handled Lotus Jug, hand painted on glaze in Mountain, 1931–2.

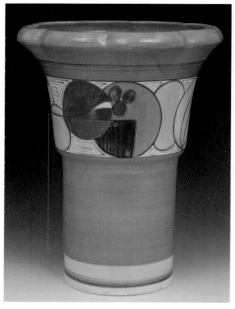

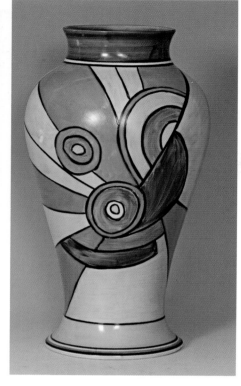

Above: A shape 374 Archaic vase hand painted on glaze in Melon, 1930.

Right: A Mei Ping vase hand painted on glaze in Sliced Circle, 1929.

A unique dish-form circular wall plaque hand painted on glaze with a stylised female figure over abstract patterned ground, unknown name but titled The Tambourine Dancer, 1932–3.

I boarded a coach for the club's tour of all the places where Clarice lived and worked during the wonderful, colourful, crazy days of the thirties. So you will understand why actually writing a book about 'our special lady' has been a great pleasure for me. Clarice has been a part of my life for as long as I can remember. And I'm sure Bizarre ware will continue to fascinate and delight many collectors for many more decades.

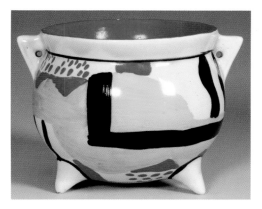

Above: A cauldron hand painted on glaze in Sunspots, *c.* 1930–1.

Below: A Pansies shape 438 cut-out with associated shape 421 fern pot hand painted on glaze, 1930.

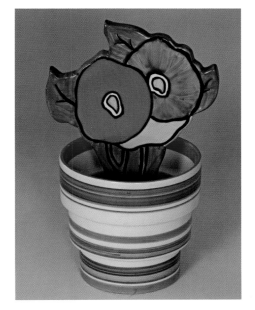

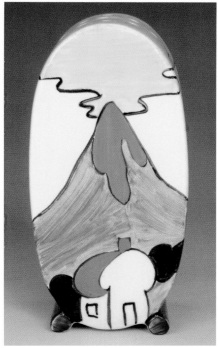

Above: A Bon Jour shape sugar sifter hand painted on glaze in Mountain, 1931.

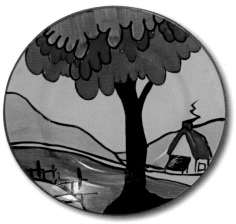

Right: A plate hand painted on glaze in House and Bridge, *c.* 1932.

INDEX